The Honolulu Academy of Arts • The Honolulu Academy of Arts • The Honolulu Academy of Arts • The Honolulu Academy of Arts • The Honolulu Academy of Arts • The Honolulu Academy of Arts • The Honolulu Academy of Arts • The Honolulu Academy of Arts • The Honolulu Academy of Arts • The Honolulu Academy of Arts • The Honolulu Academy of Arts • The Honolulu Academy of Arts • The Honolulu Academy of Arts • The Honolulu Academy of Arts • The Honolulu Academy of Arts • The Honolulu Academy of Arts • The Honolulu Academy of Arts • The Honolulu Academy of Arts • The Honolulu Academy of Arts

A MUSEUM FOR EVERYONE!

by Susan Soong

ISBN 0-937426-32-6

 SECOND PRINTING, 1997

In 1927, Anna Rice Cooke donated the site of her home to create a new museum.

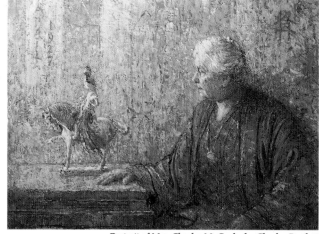

Portrait of Mrs. Charles M. Cooke by Charles Bartlett

With the spirit of aloha, the Honolulu Academy of Arts was established "as a place where all people would be welcome."

E komo mai

The museum is for everyone who...

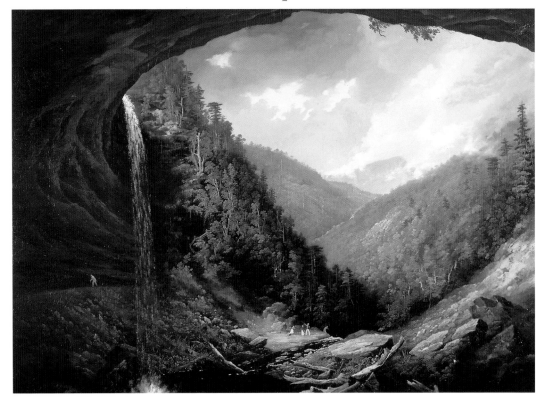

seeks adventure

and dreams

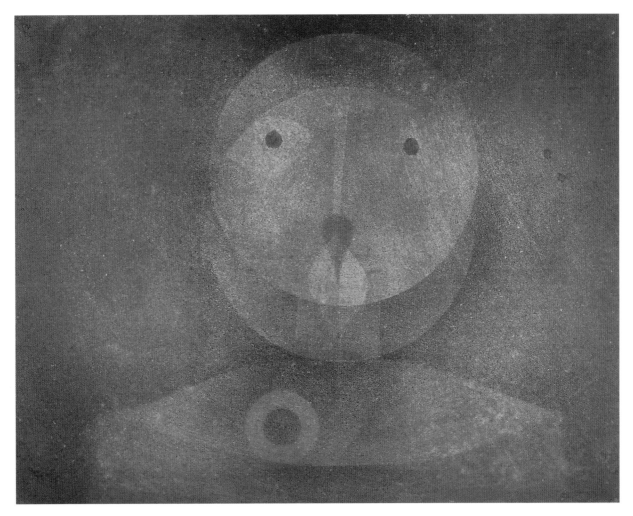

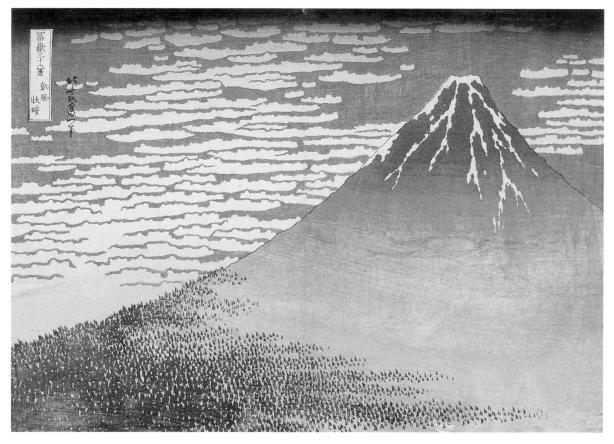

of faraway places.

Anyone who

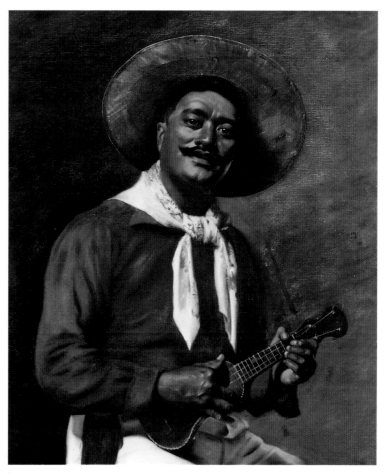

returns a troubador's smile

or a
lady's
gracious
gaze

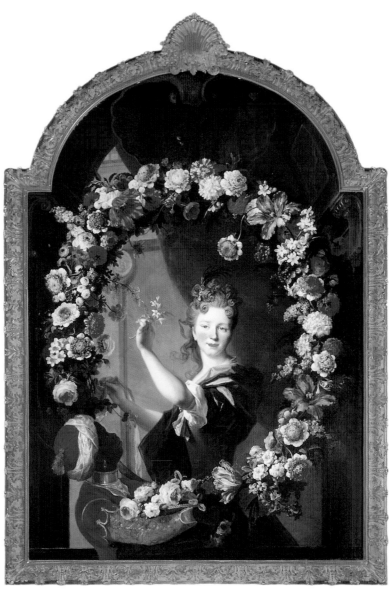

who sways with the wind

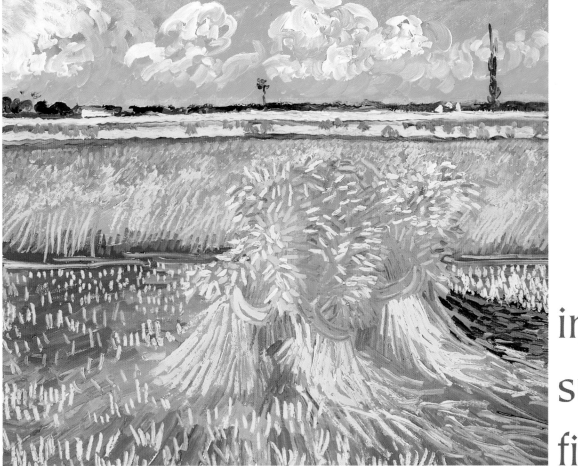

in a
sunlit
field

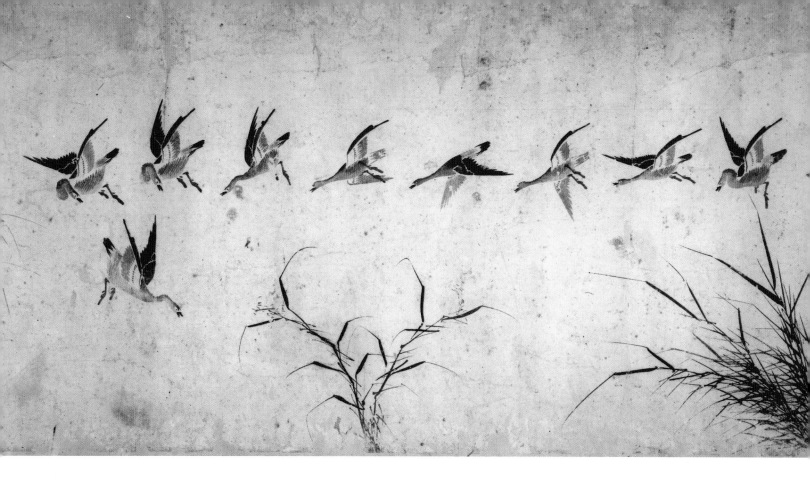

and watches in silence

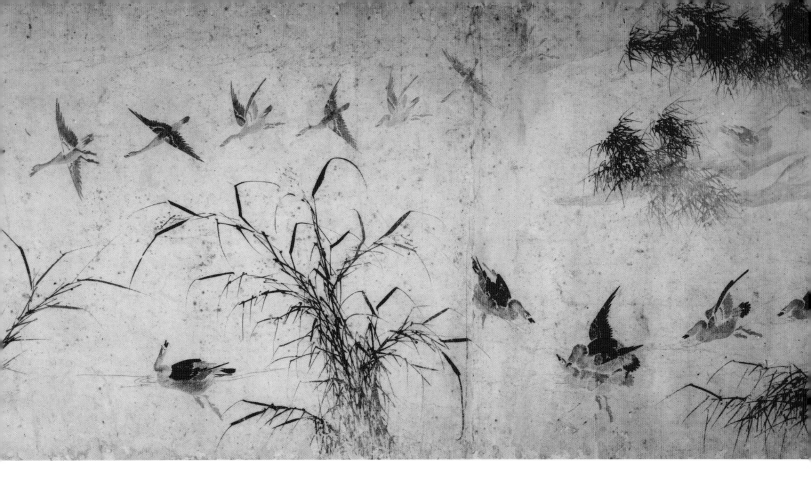

as a hundred geese take flight.

Do you see clouds

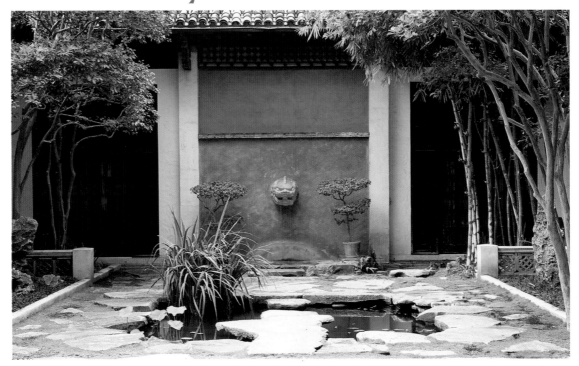

mirrored in a pond

and water lilies

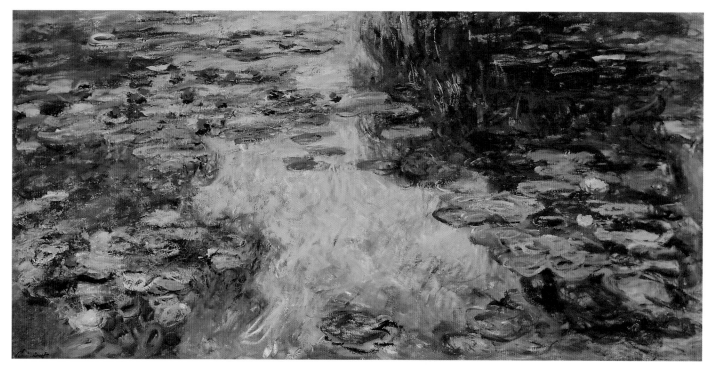

blooming year-round?

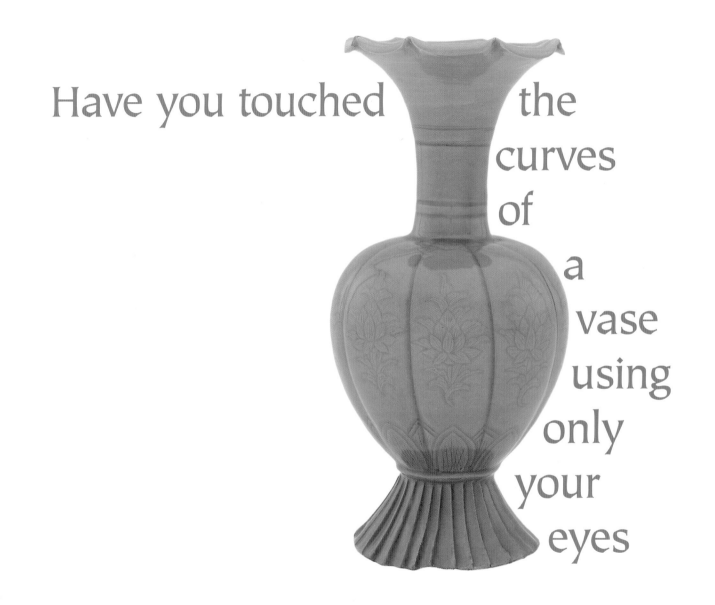

Have you touched the curves of a vase using only your eyes

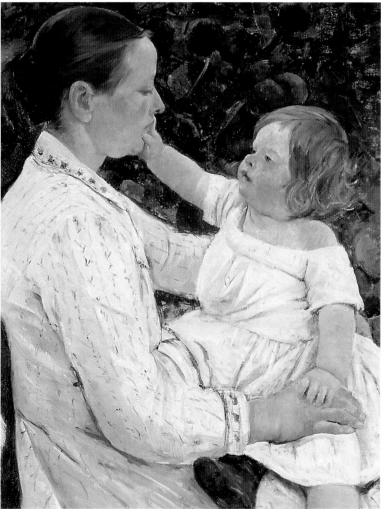

or been
touched by
a loving
caress?

The museum
is for everyone

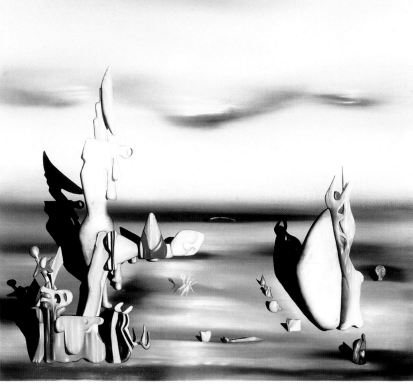

who dares to imagine

or simply sees

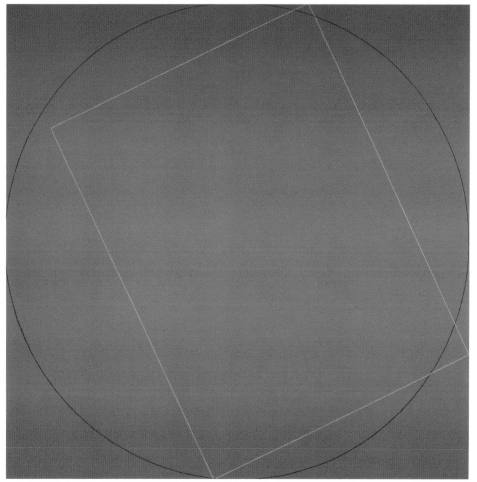

a rectangle,

a circle,

a square,

six persimmons

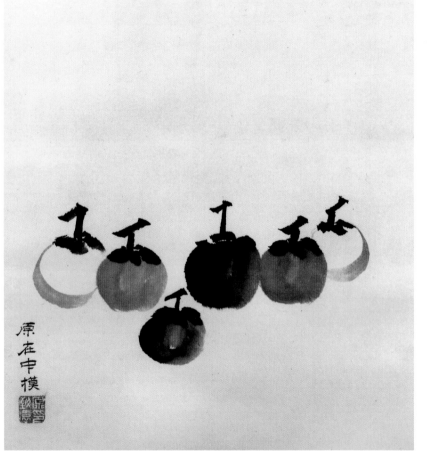

and 1,000 flowers blossoming

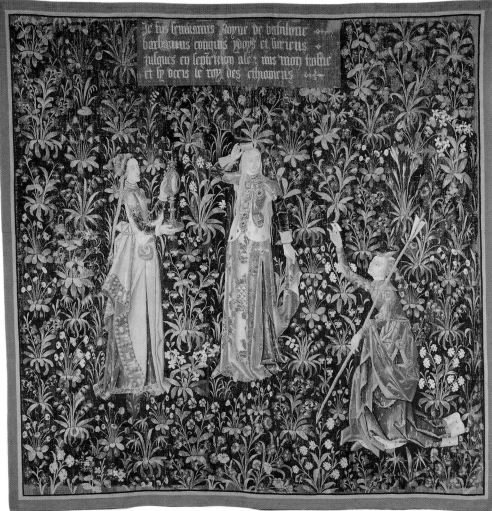

in silken threads.

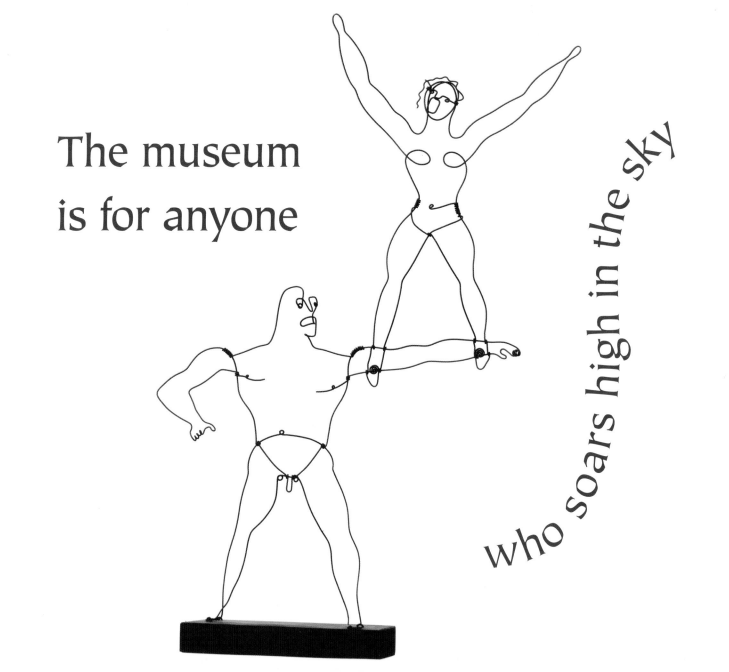

The museum
is for anyone

who soars high in the sky

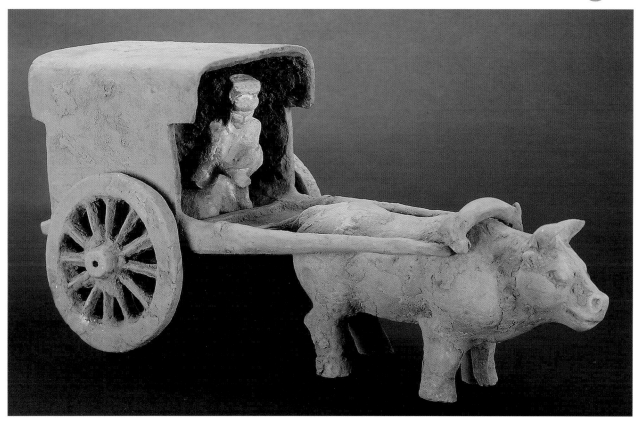

lonely deep canyons…

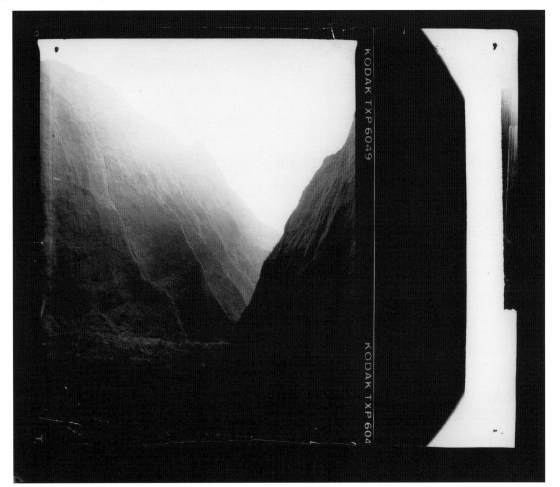

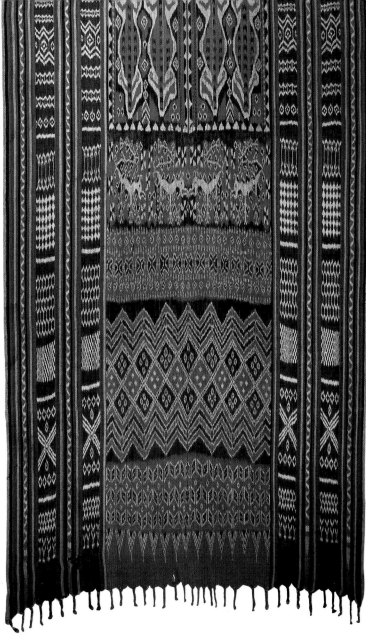

who gets lost
in a maze
of pattern,

discovers 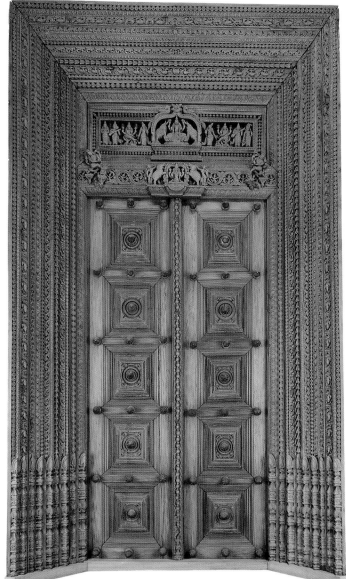 a door

or perhaps a window

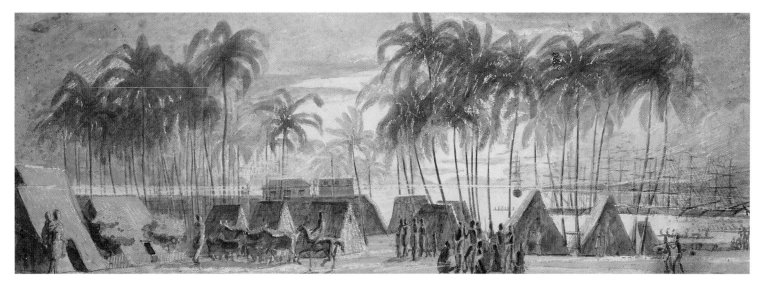

to escape to the past

and
wonders
what is

at the end of a rainbow.

The Honolulu Academy of Arts...

A MUSEUM FOR YOU.

List of Plates

page 29 details:

PIERRE MIGNARD
French, 1612-95
The Children of the Duc de Bouillon, 1647
Oil on canvas; 35 x 46 3/4 in.
Purchase, Robert Allerton Fund, 1975

NICOLAS DE LARGILLIÈRE
French, 1656-1746

JEAN-BAPTISTE BLIN DE FONTENAY
French, 1653-1715
Hélène Lambert de Thorigny, ca. 1695-1700
Oil on canvas; 63 x 45 in.
Purchase, 1969

PIERRE-AUGUSTE RENOIR
French, 1841-1919
Dance in the Country, 1883
Carbon pencil on paper; 19 1/4 x 13 5/8 in.
Purchase, 1937

HEAD OF A SATYR
Roman, 2nd century
Marble; h. 8 7/8 in.
Gift of Daphne Damon in memory of
Violet D. Putnam, 1957

HUBERT VOS
American, 1855-1935
Kolomona: Hawaiian Troubadour, 1898
Oil on canvas; 40 x 35 in.
Gift of Henry B. Clark, Jr. in memory of
Dr. and Mrs. Frank L. Putnam, 1994

ROBERT DELAUNAY
French, 1885-1941
Rainbow, 1913
Oil on canvas; 34 9/16 x 39 5/16 in.
Purchase, 1966

Credits and Acknowledgments

Honolulu Academy of Arts
George Ellis, *Director*
Karen Thompson, *Curator of Education*
Jennifer Saville, *Curator of Western Art*
Stephen Little, *Curator of Asian Art (past)*
Tibor Franyo, *Photographer*

Susan Soong, *Creative Concept & Text*

Sherri Kandell, *Kandell Advertising, Creative Director*
Sam Kim, *Spike! Inc., Book Design*

Lisa Erb, *Editor*
William Loh, *Chinese Calligraphy*

Proceeds to benefit the Honolulu Academy of Arts.

謹以此懷念錄獻給我最敬愛的先父
毛澤太公與先毋陳氏金好太夫人

In loving memory of my parents — Chuck and Karen Chun-Hoon Mau